D0167809

*Lilith*

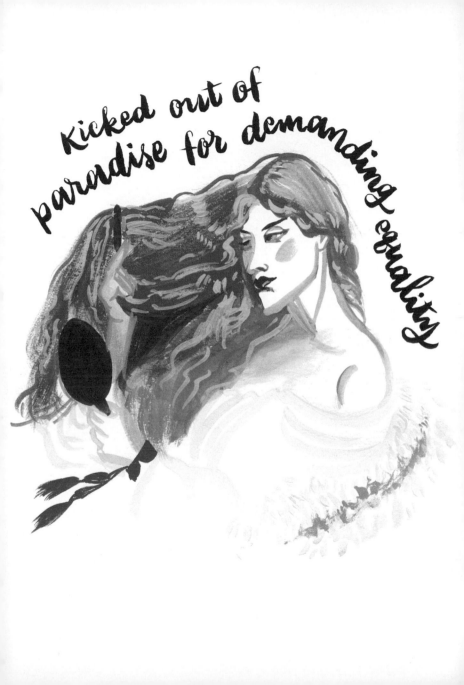

_Cleopatra_ (69–30 B.C.E.)

The
one and
only
Empress
of
China

_Empress Wu Zetian_ (624–705)

_Lady Godiva_ (1040–1067)

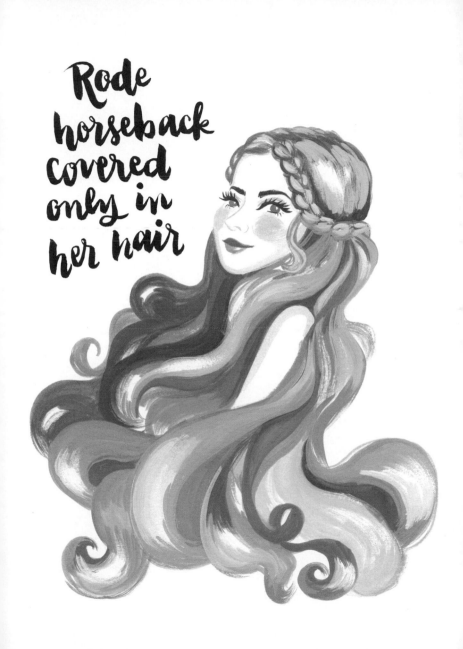

Rode
horseback
covered
only in
her hair

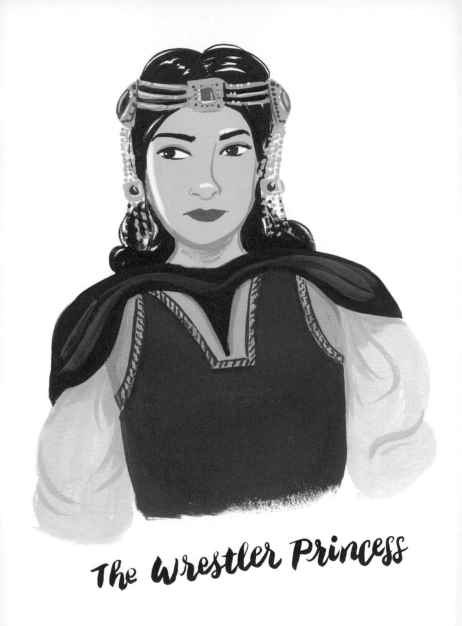

The Wrestler Princess

_Khutulun_ (1260–1306)

Called by
God
to save
France

*Joan of Arc* (1412–1431)

*Aphra Behn* (1640–1689)

First professional female writer

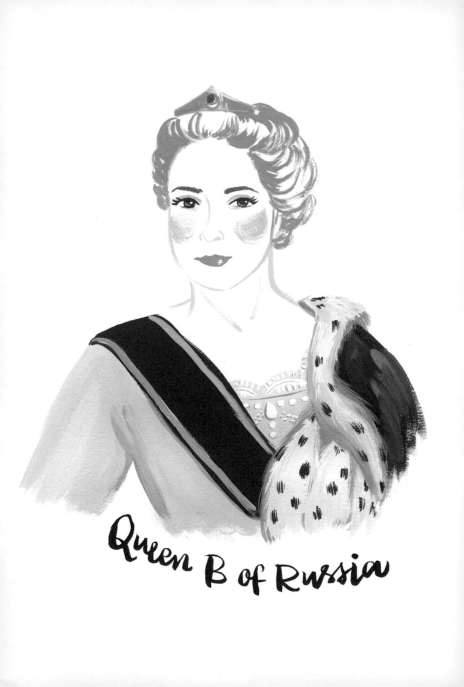

Queen B of Russia

*Catherine the Great* (1729–1796)

_Marie Antoinette_ (1755–1792)

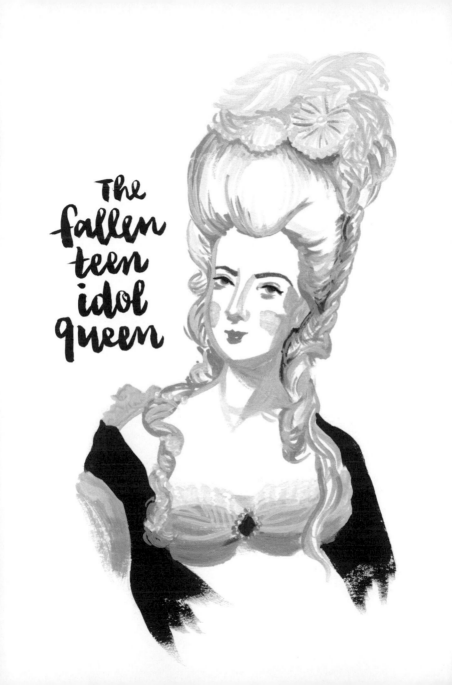

The
fallen
teen
idol
queen

Portrait
painter
to the
aristocratic
stars

_Élisabeth Vigée-Lebrun_ (1755–1842)

*Sojourner Truth* (ca. 1797–1883)

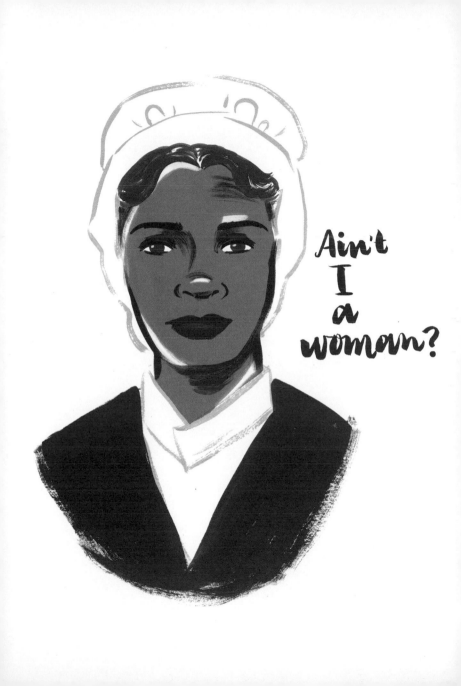

Ain't
I
a
woman?

_Maria Mitchell_ (1818–1889)

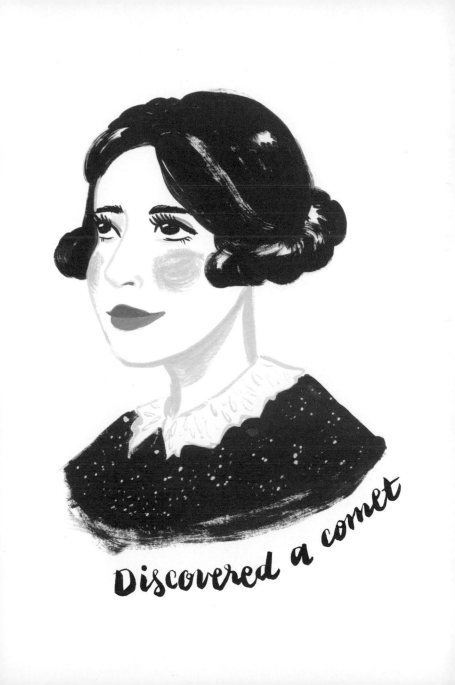

Discovered a comet

*Susan B. Anthony* (1820–1906)

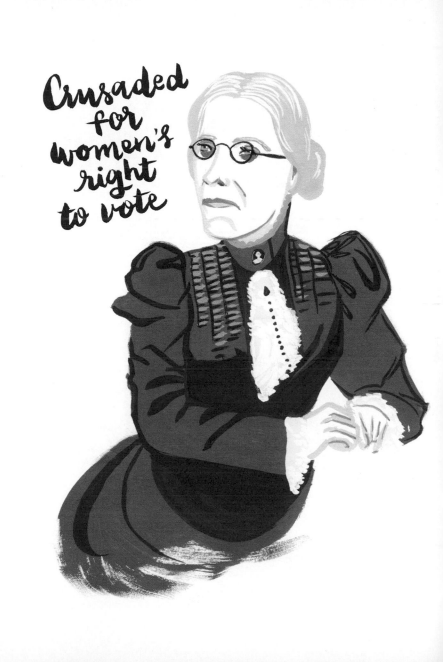

Crusaded for women's right to vote

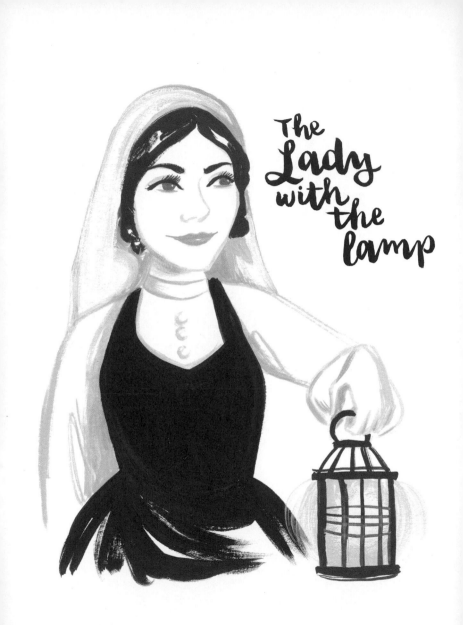

The
Lady
with
the
lamp

*Florence Nightingale* (1820–1910)

_Harriet Tubman_ (ca. 1822–1913)

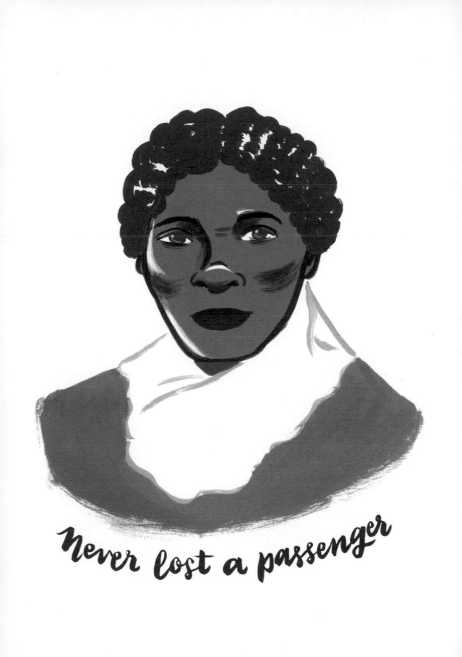

Never lost a passenger

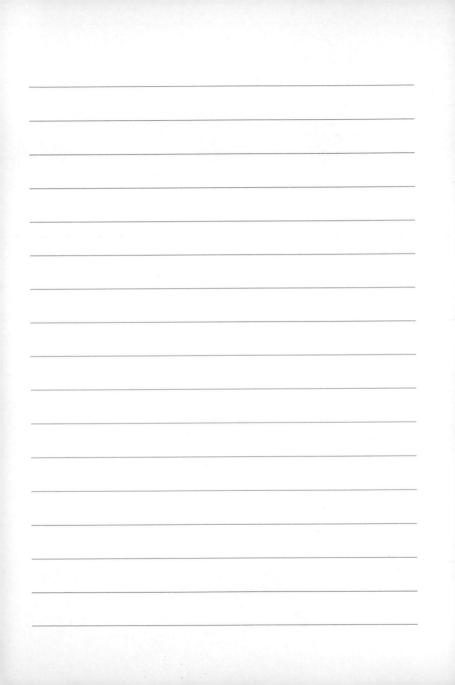

First
female
sharpshooter

*Annie Oakley* (1860–1926)

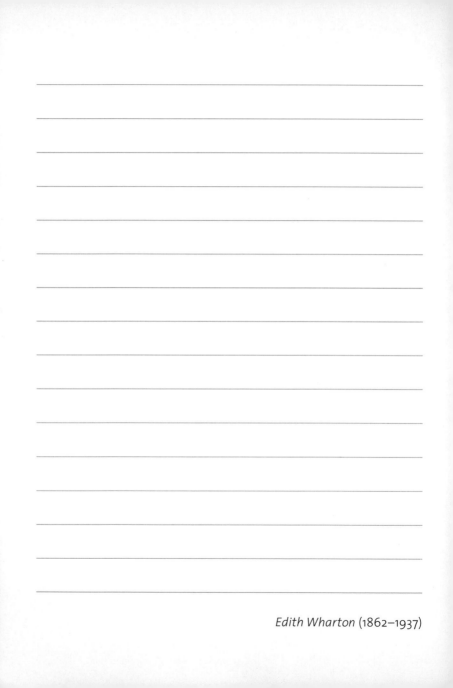

*Edith Wharton* (1862–1937)

First woman to win a Pulitzer Prize

_Nellie Bly_ (1864–1922)

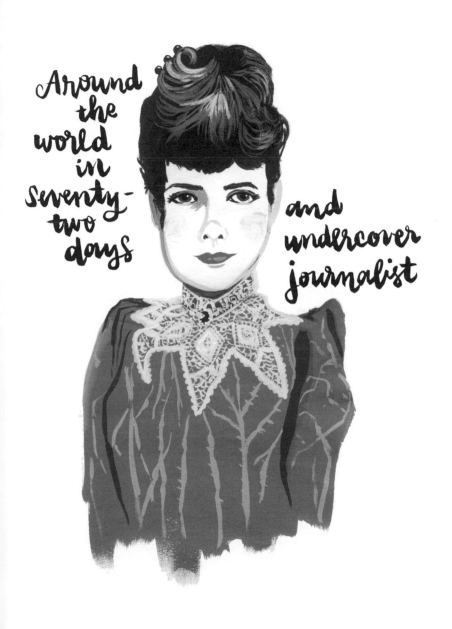

Around the world in seventy-two days and undercover journalist

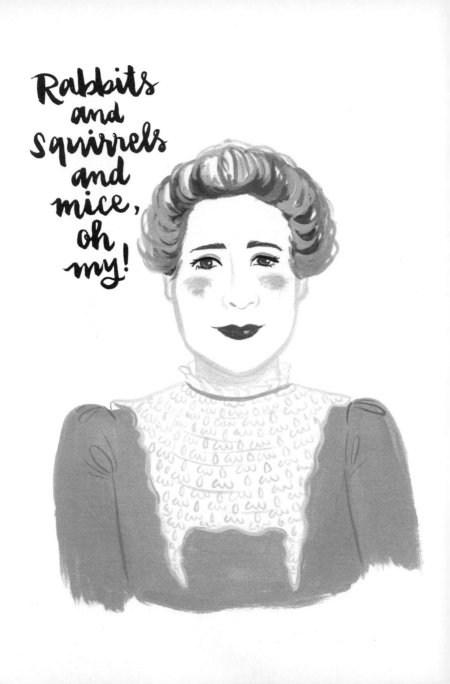

_Beatrix Potter_ (1866–1943)

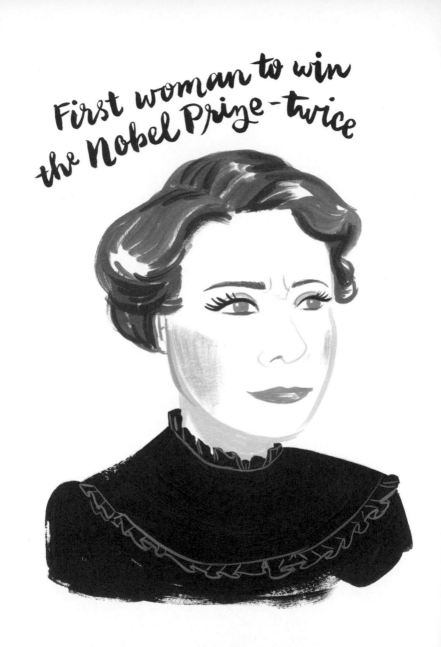

_Marie Curie_ (1867–1934)

_Alice Guy-Blaché_ (1873–1968)

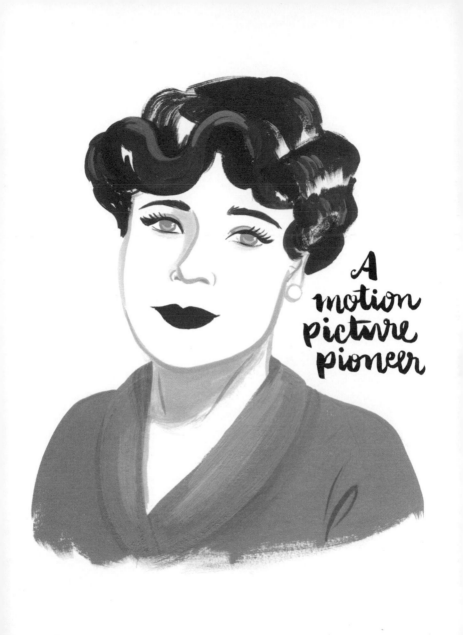

A motion picture pioneer

*Mata Hari* (1876–1917)

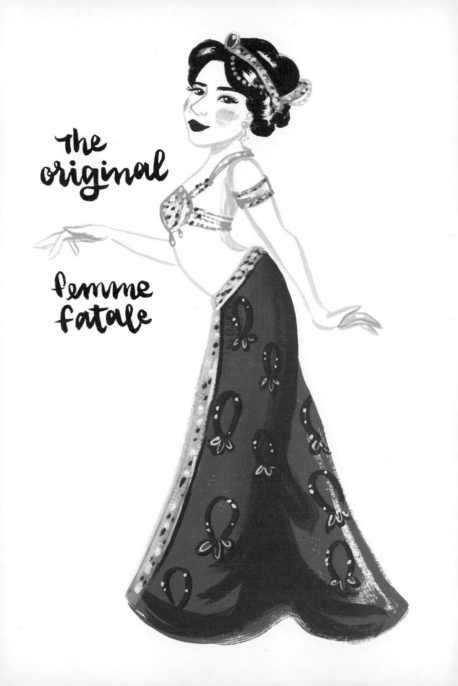

the
original

femme
fatale

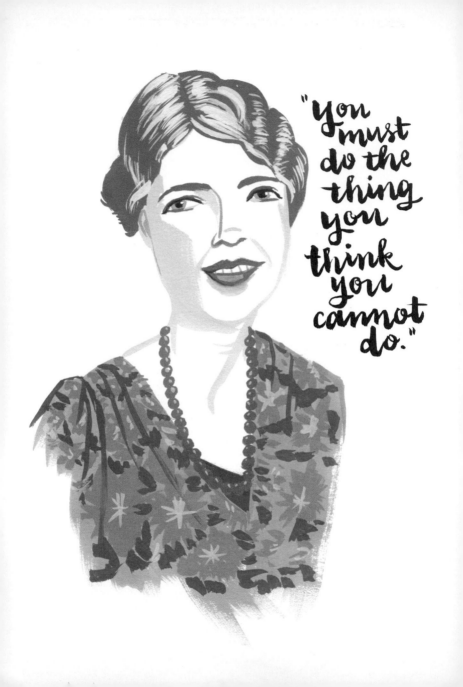

"You must do the thing you think you cannot do."

*Eleanor Roosevelt* (1884–1962)

Mother
of
American
Modernist
Art

_Georgia O'Keeffe_ (1887–1986)

Elsa Schiaparelli (1890–1973)

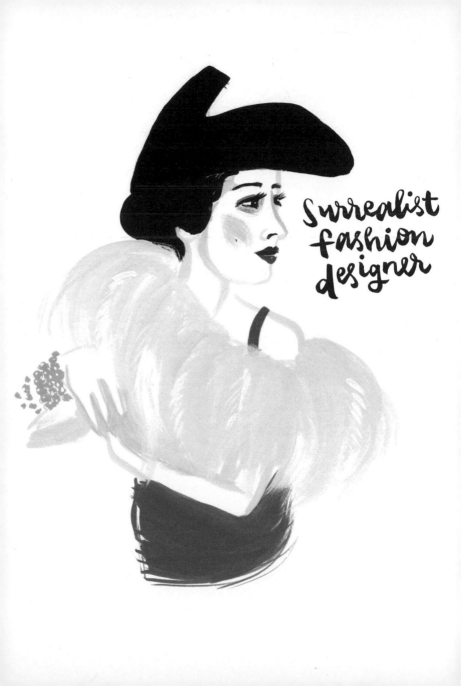

surrealist
fashion
designer

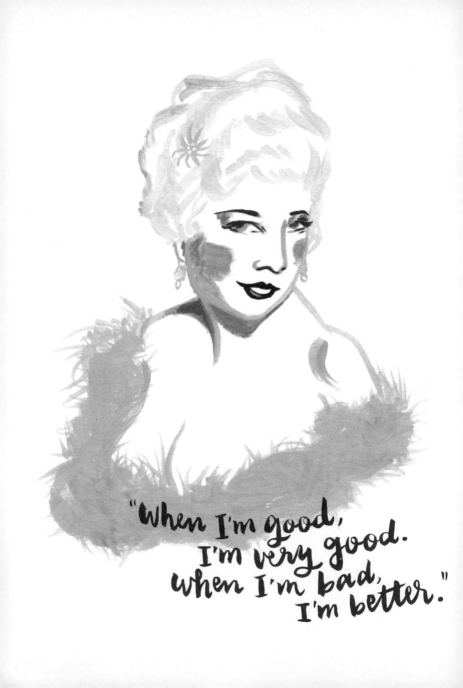

"When I'm good,
I'm very good.
when I'm bad,
I'm better."

_Mae West_ (1893–1980)

Martha Graham (1894–1991)

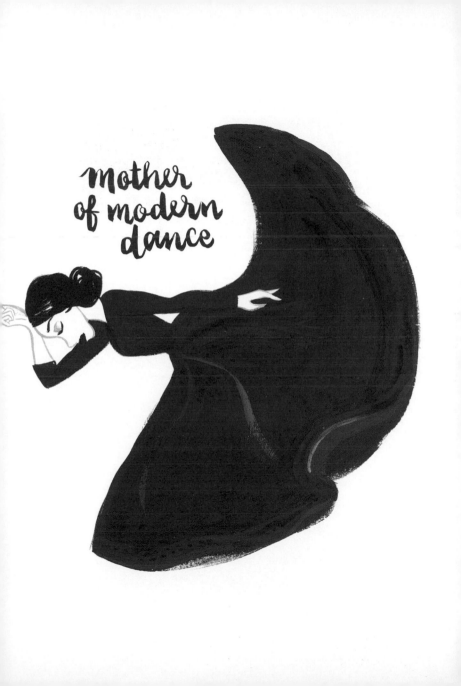

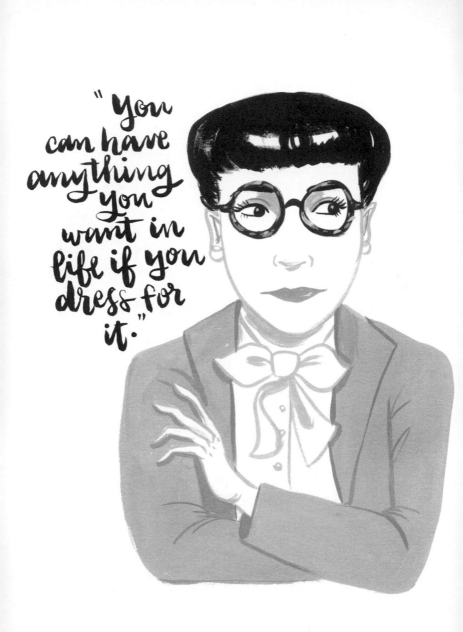

_Edith Head_ (1897–1981)

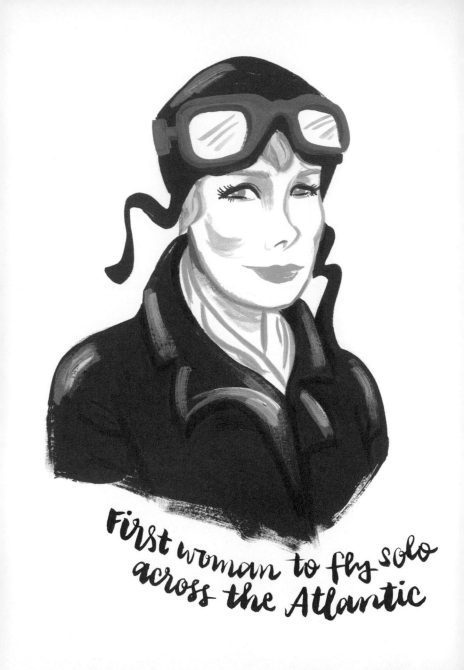

First woman to fly solo
across the Atlantic

*Amelia Earhart* (1897–1937)

Anaïs Nin (1903–1977)

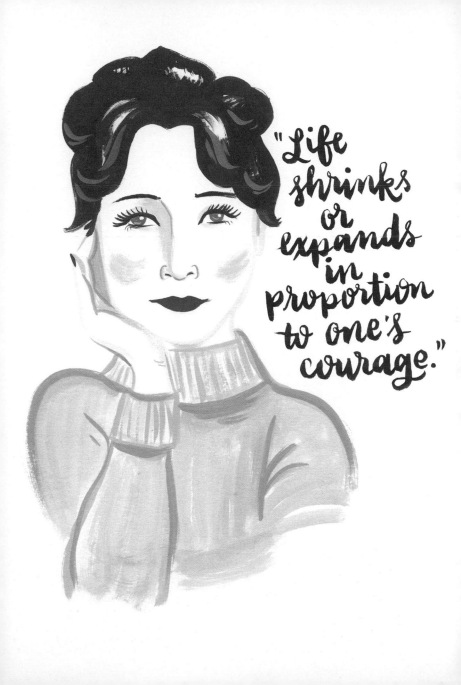

"Life shrinks or expands in proportion to one's courage."

_Anna May Wong_ (1905–1961)

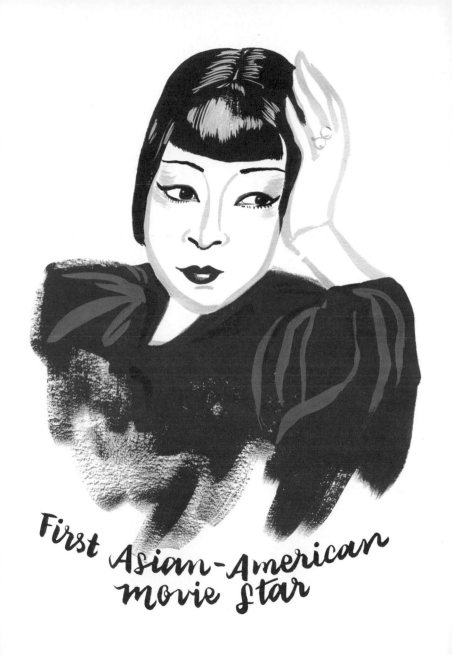

First Asian-American movie star

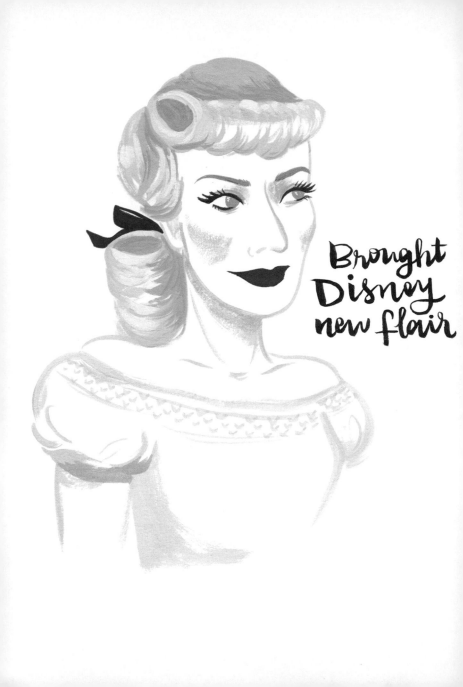

Brought
Disney
new flair

*Mary Blair* (1911–1978)

_Gypsy Rose Lee_ (1911–1970)

Put
her wit
in her tease

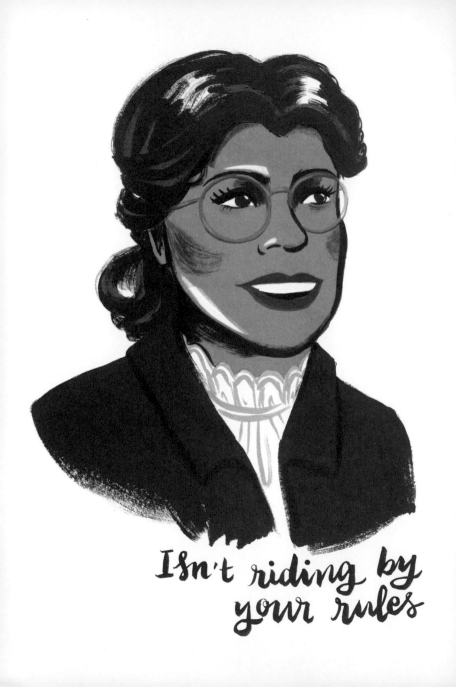

Isn't riding by
your rules

*Rosa Parks* (1913–2005)

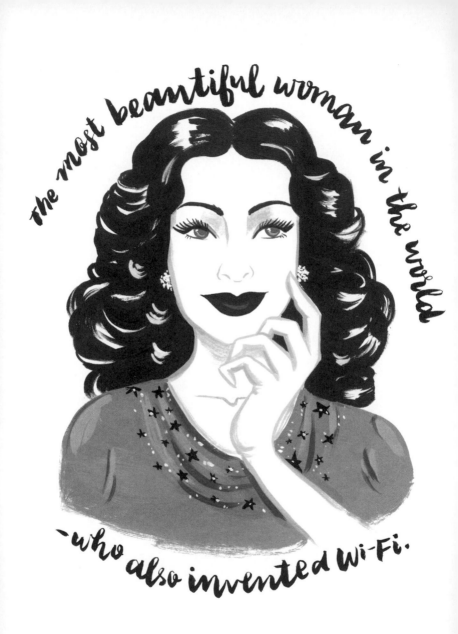

*Hedy Lamarr* (1914–2000)

_Billie Holiday_ (1915–1959)

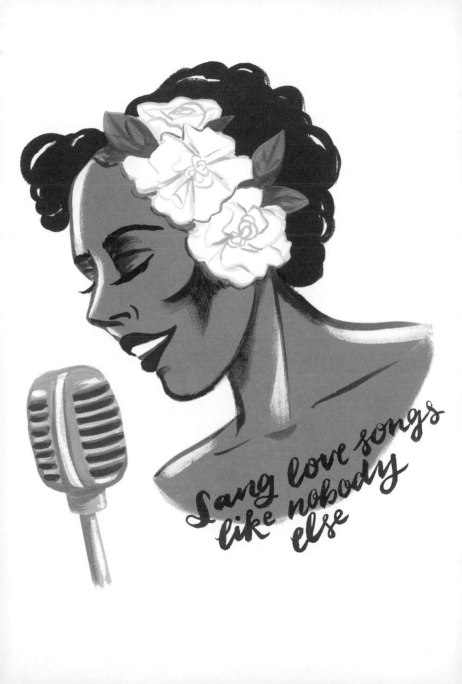

*Dorothy Dandridge* (1922–1965)

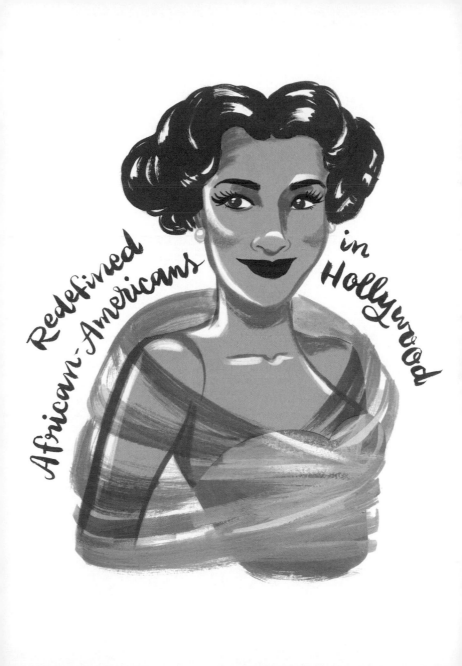
Redefined African-Americans in Hollywood

_Bettie Page_ (1923–2008)

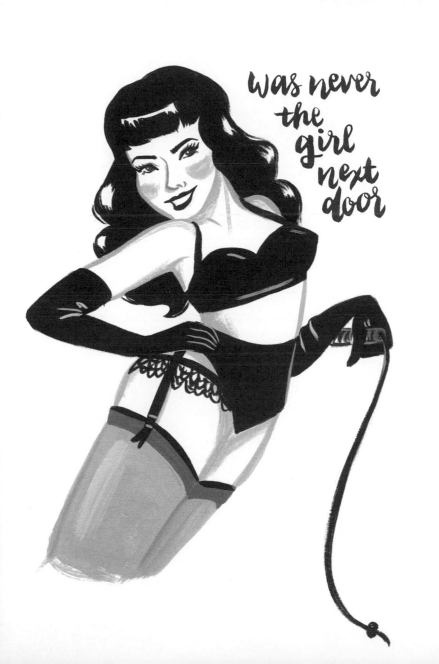

was never the girl next door

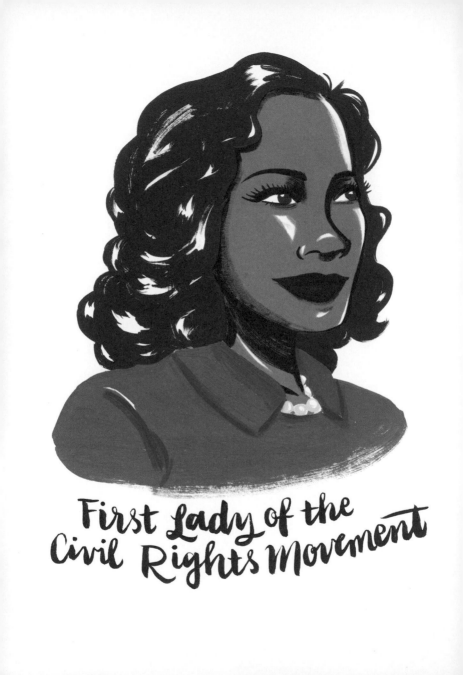

First Lady of the Civil Rights Movement

*Coretta Scott King* (1927–2006)

_Ruth Westheimer_ (1928– )

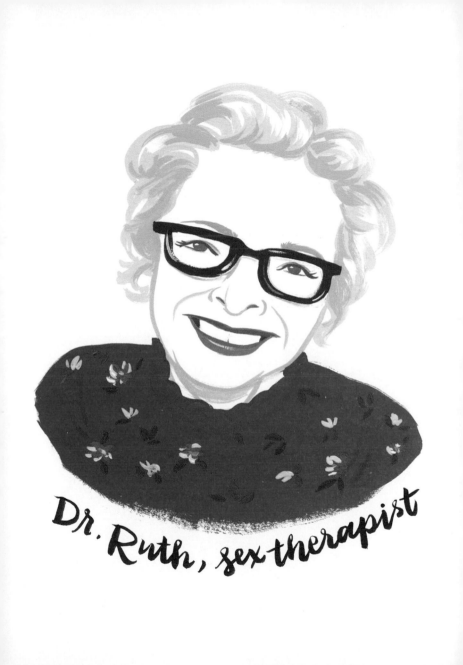

Dr. Ruth, sex therapist

From "A Bunny's Tale" to MS. magazine

_Gloria Steinem_ (1934– )

*Valentina Tereshkova* (1937– )

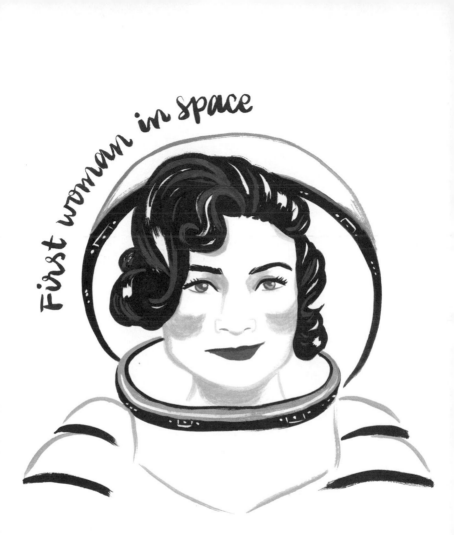

First woman in space

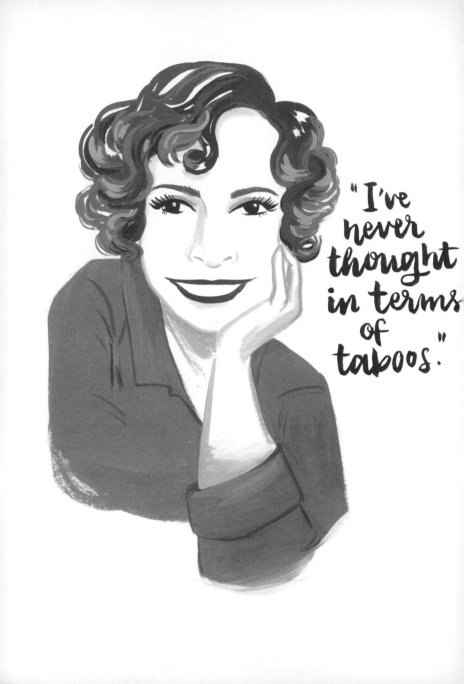

"I've never thought in terms of taboos."

_Judy Blume_ (1938– )

Junko Tabei (1939–2016)

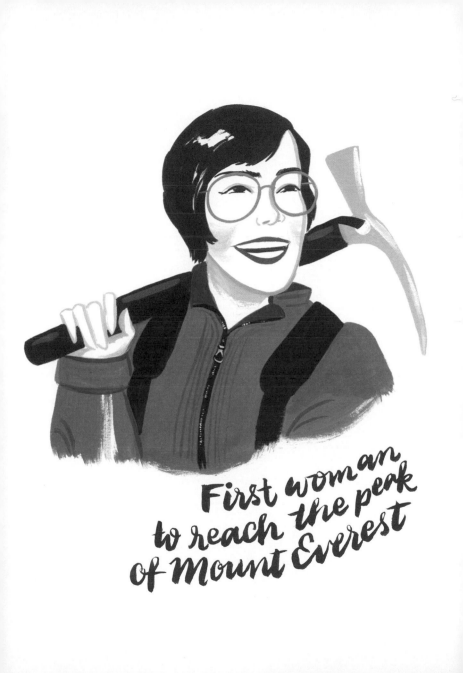

First woman
to reach the peak
of Mount Everest

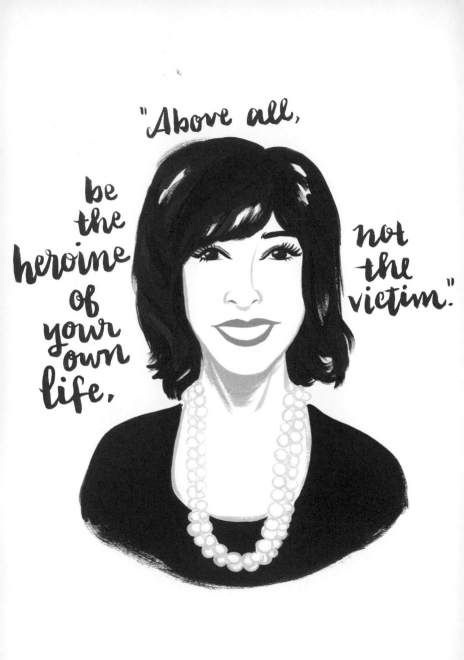

"Above all, be the heroine of your own life, not the victim."

_Nora Ephron_ (1941–2012)

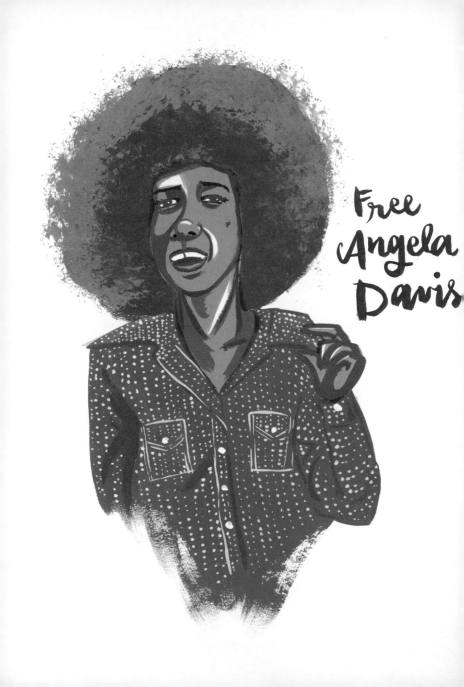

*Angela Davis* (1944– )

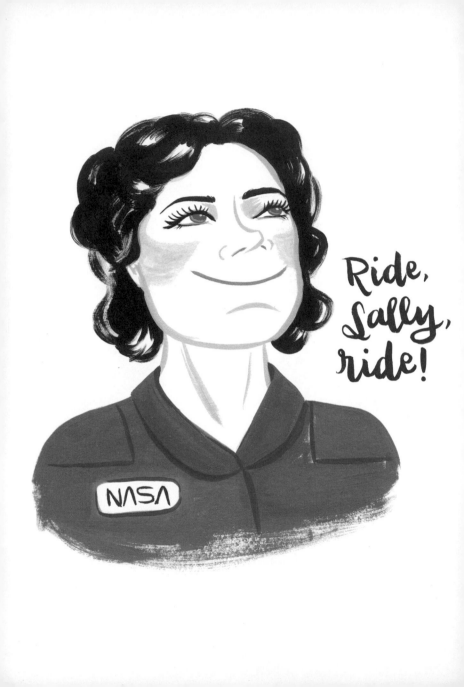

Ride, Sally, ride!

*Sally Ride* (1951–2012)

_Oprah Winfrey_ (1954– )

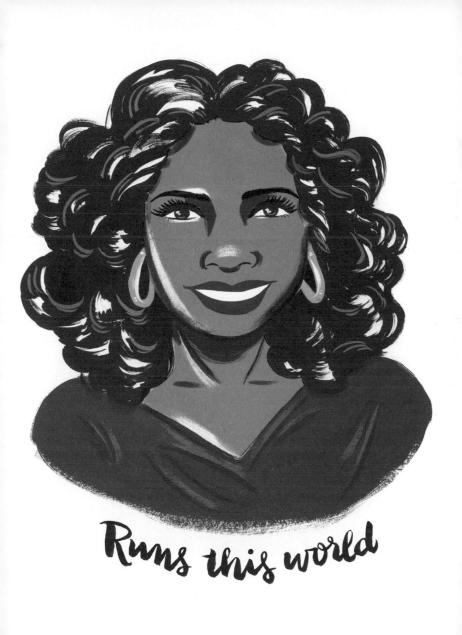

Runs this world

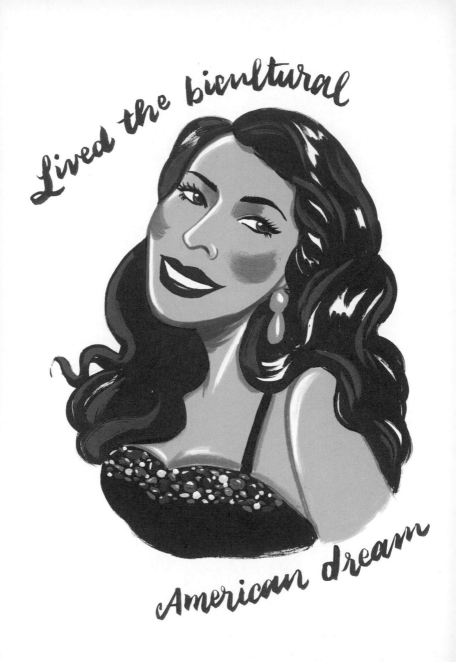

*Selena* (1971–1995)

stands for books, not bullets

*Malala Yousafzai* (1997– )